How to Draw
Trees

In Simple Steps

Denis John-Naylor

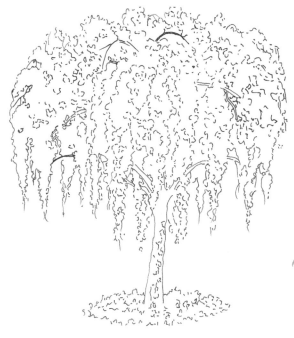

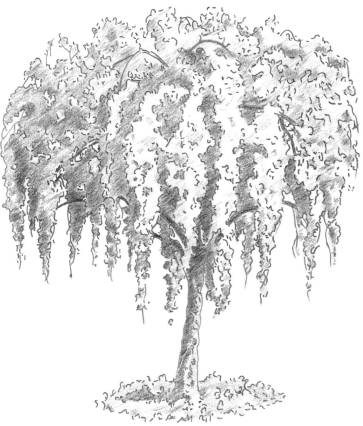

Search Press

Introduction

Trees are interesting and varied subjects to draw and improving your tree drawing ability will also improve your ability to draw other subjects. It is likely that a variety of trees are available locally for most of us to observe and draw, and being a subject that changes throughout the seasons, trees can be drawn often as they grow and change. They can be sketched displaying their early yellow-green leaves of spring, flowering and bearing fruit, in summer's full, green leaf stage, yielding richly-coloured leaves and seeds in the autumn, and finally, in their dry winter state.

As you work through the examples in this book, also take the opportunity to observe trees at first hand whenever you can. Half closing your eyes will reduce an observed tree to its simplest form; thus eliminating unnecessary detail. We begin our tree drawings with this simplest form, and in easy-to-follow steps, add detail and structure as we progress. This sets a sound basis for all your drawing work that follows.

I would suggest that the initial guidelines shown in step one are faintly drawn in order to make their eventual removal easier. In step two the guidelines remain to help you begin the drawing proper, which is shown in colour for easy reference. All subsequent step progress is also shown in colour to highlight additional lines while your drawing continues in pencil throughout.

Notice the use of broken outlines, consisting of dots, squiggles and dashes. These are quite abstract in themselves but form a pattern of shapes to work within. These abstract marks also help to give the feeling of an irregular softness for the clusters of leaves or foliage, whereas bold, unbroken lines are used for trunks and branches, giving them solidity by comparison. Tree trunks and branches tend to disappear into the leaf clusters, but sometimes reappear between the foliage. Note also that in the main, branches only get thinner from that point where another branch occurs.

Steps three and four complete the main line-work and look more closely at the internal details. Step five develops the drawing to show how shading is added to give the drawing some depth and form. The final step shows a full-colour painting of the tree, which has been executed using acrylic paints.

I suggest you use an HB pencil, lightly, for your initial guidelines, then a B grade for main outlines and a 2B for the shaded areas. Sharpen your pencils to a long point so that you can use the tip or the side to make different marks. Shading or toning can be achieved using the side of the pencil as an alternative to hatching with lines, but try both to see which best suits your style of drawing.

The more time you spend drawing trees, the more proficient you will become and this will enable you to evolve your own distinctive style. Accomplished tree drawing is within everyone's grasp – it just requires practice.

Happy drawing!

How to Draw
Trees
In Simple Steps

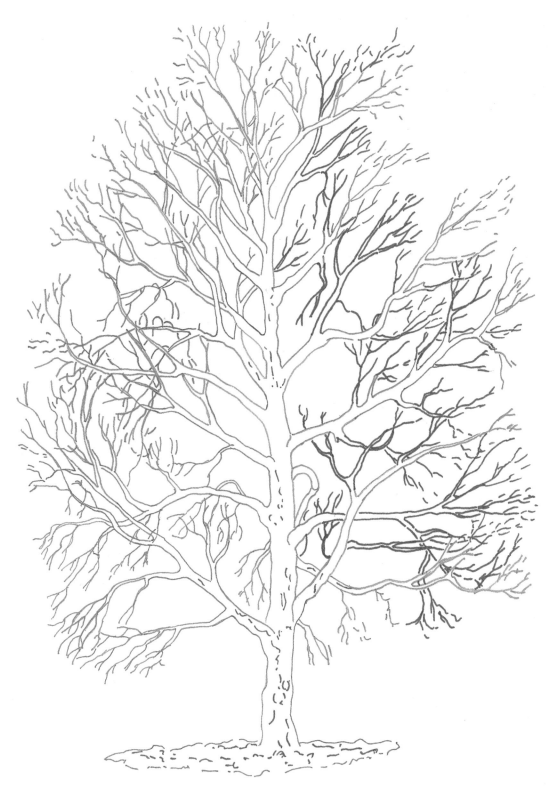

First published in Great Britain 2011

Search Press Limited
Wellwood, North Farm Road,
Tunbridge Wells, Kent TN2 3DR

Reprinted 2012 (twice), 2015

Text copyright © Denis John-Naylor 2011

Design and illustrations copyright © Search Press Ltd. 2011

ISBN: 978-1-84448-373-0

Printed in Malaysia

Dedication

*Dedicated to my eldest brother 'Fred'
(1933– 2010)*

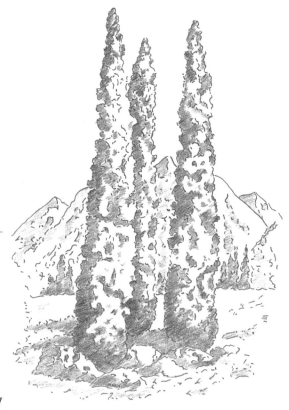

Illustrations

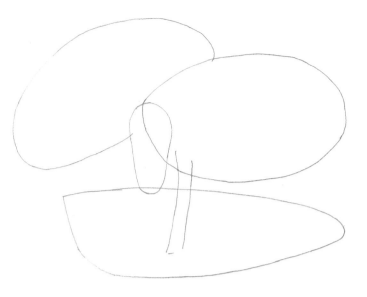

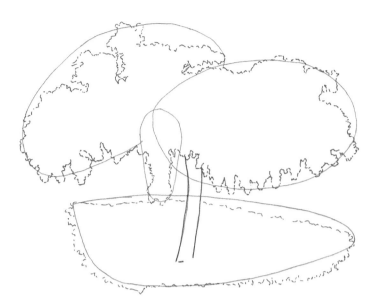

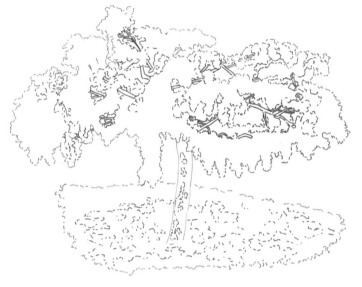

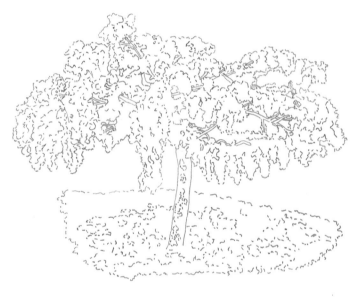

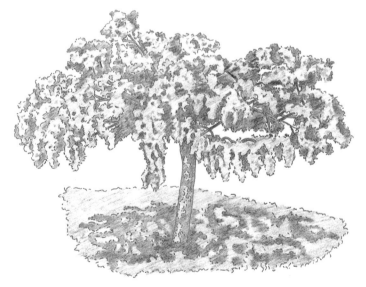

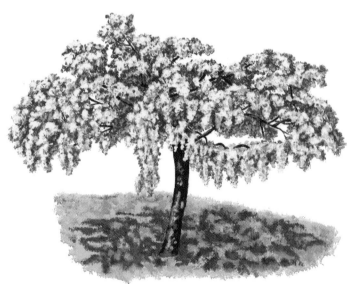

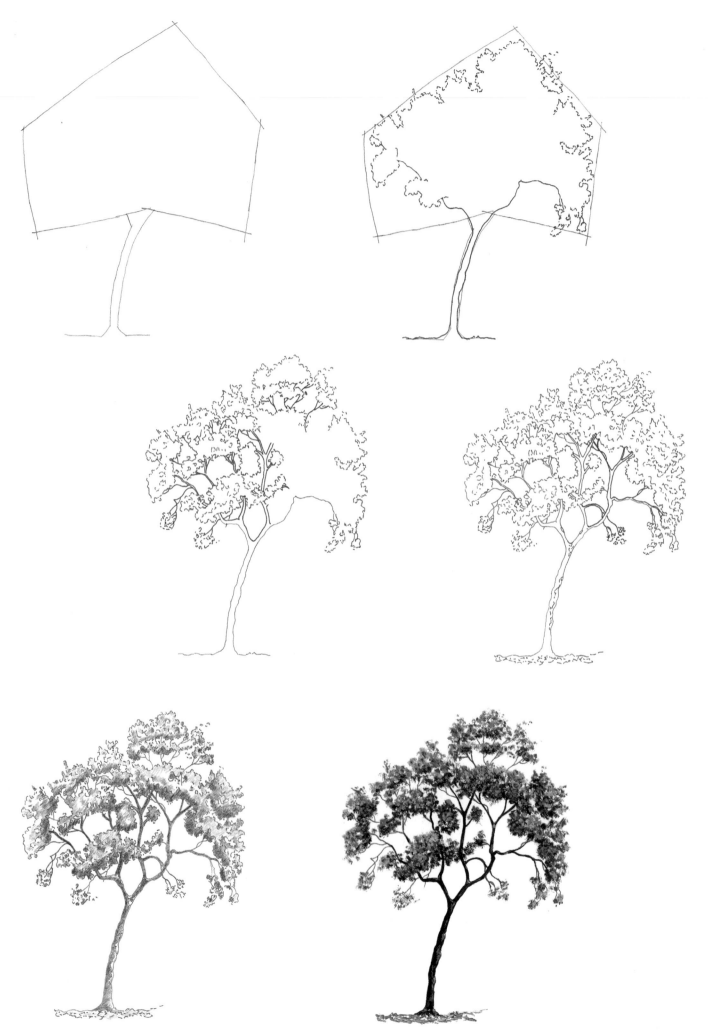

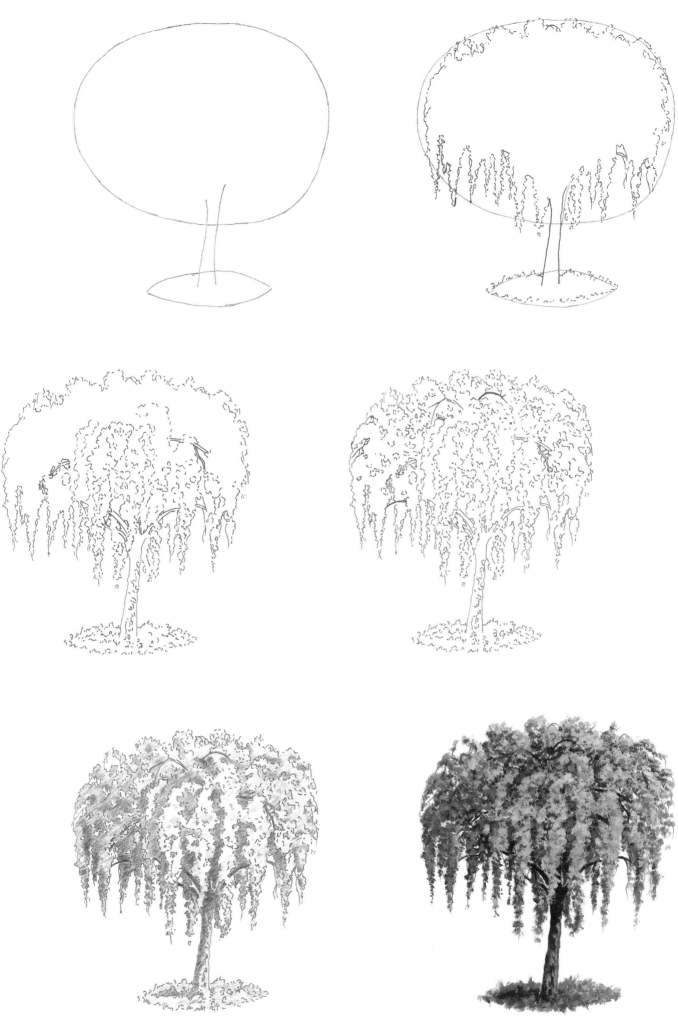

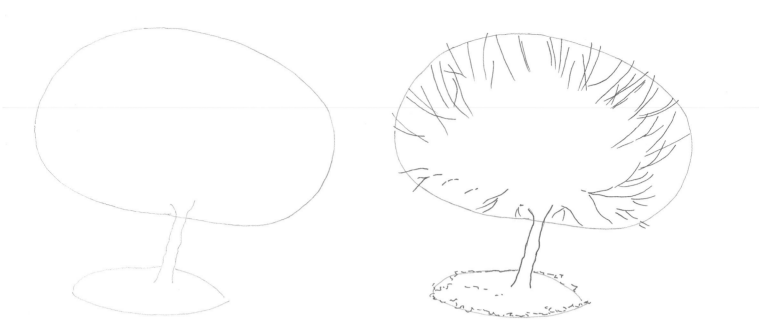

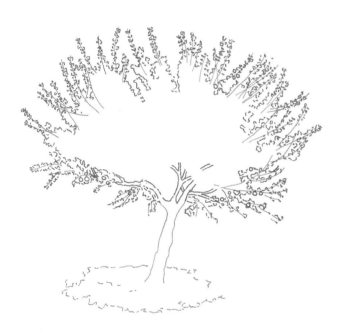

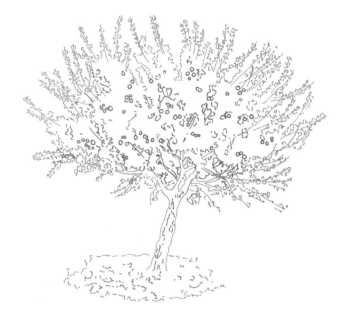

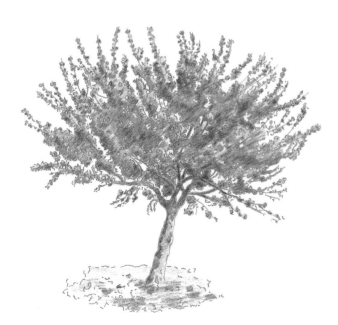

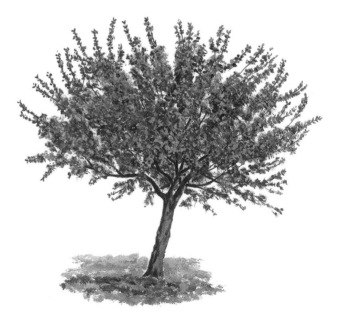

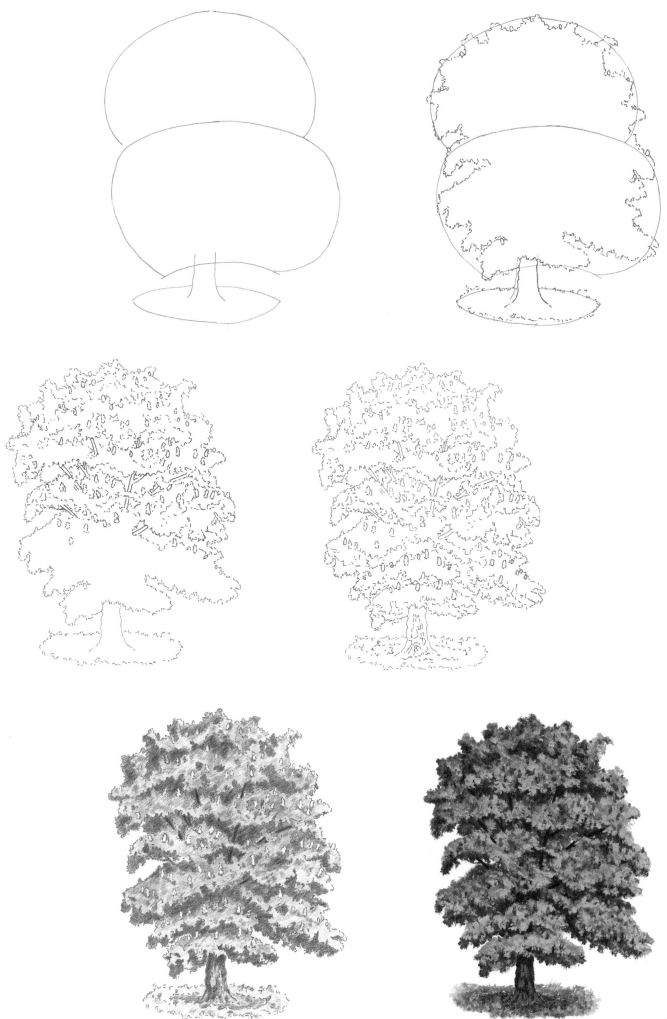

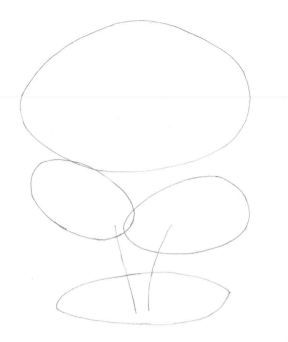

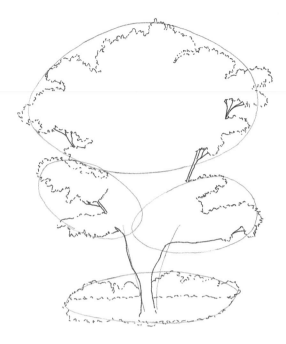

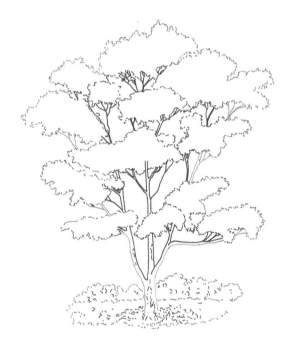

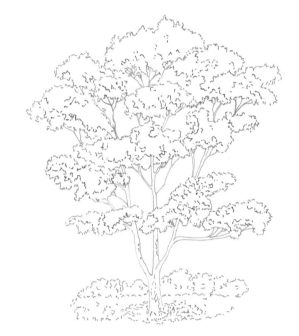

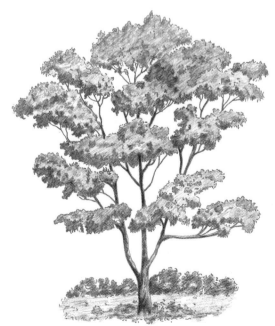

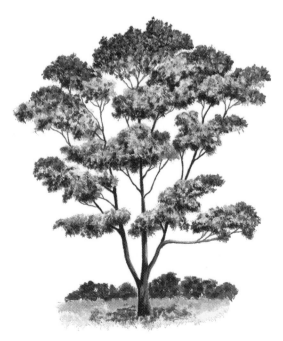

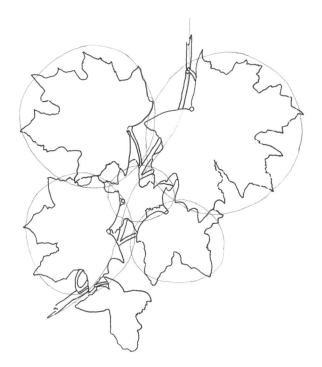
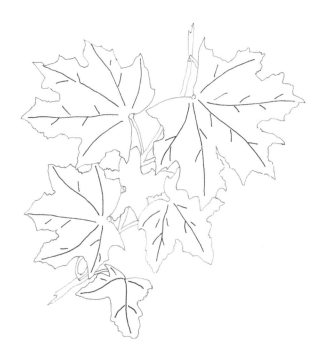
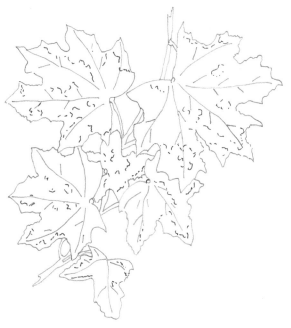
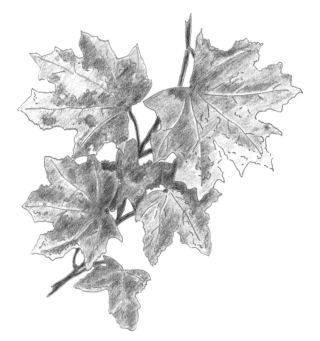
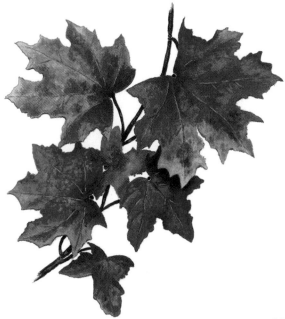

11

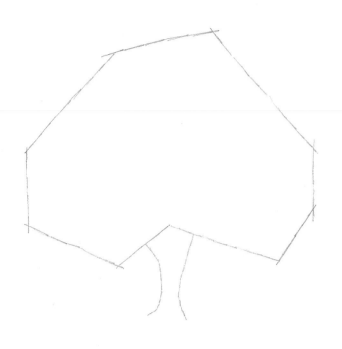

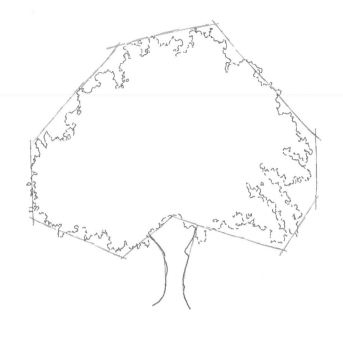

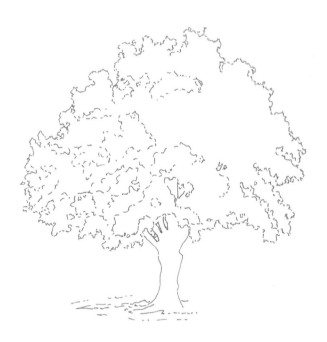

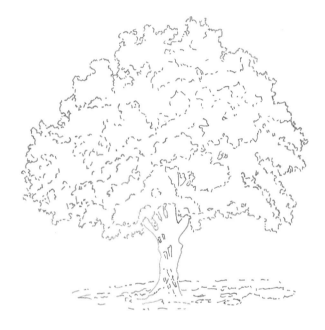

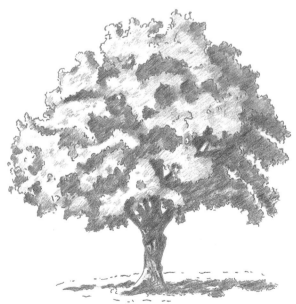

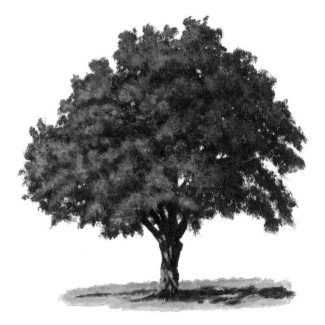

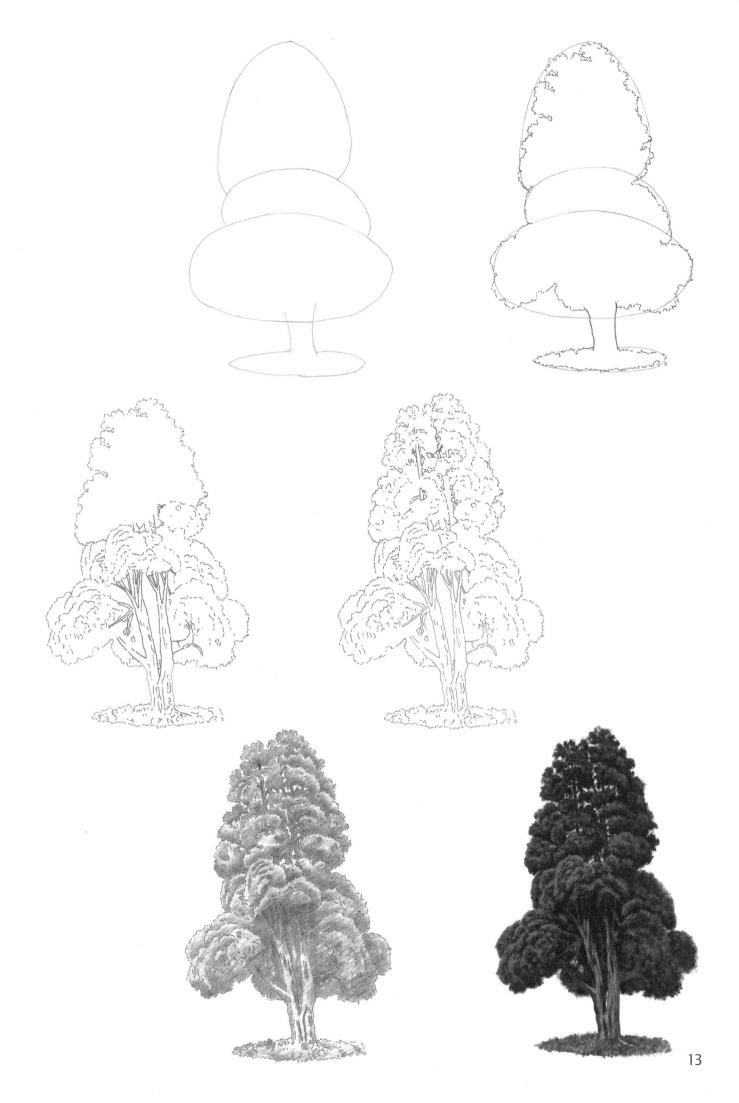

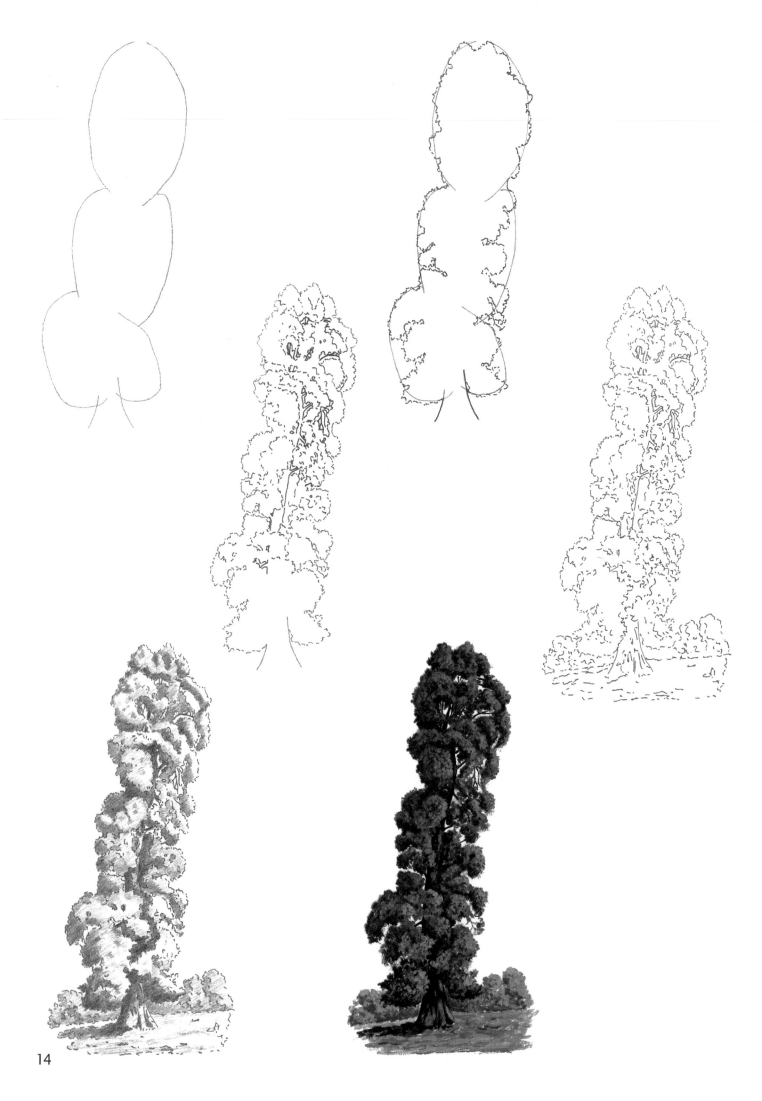

14

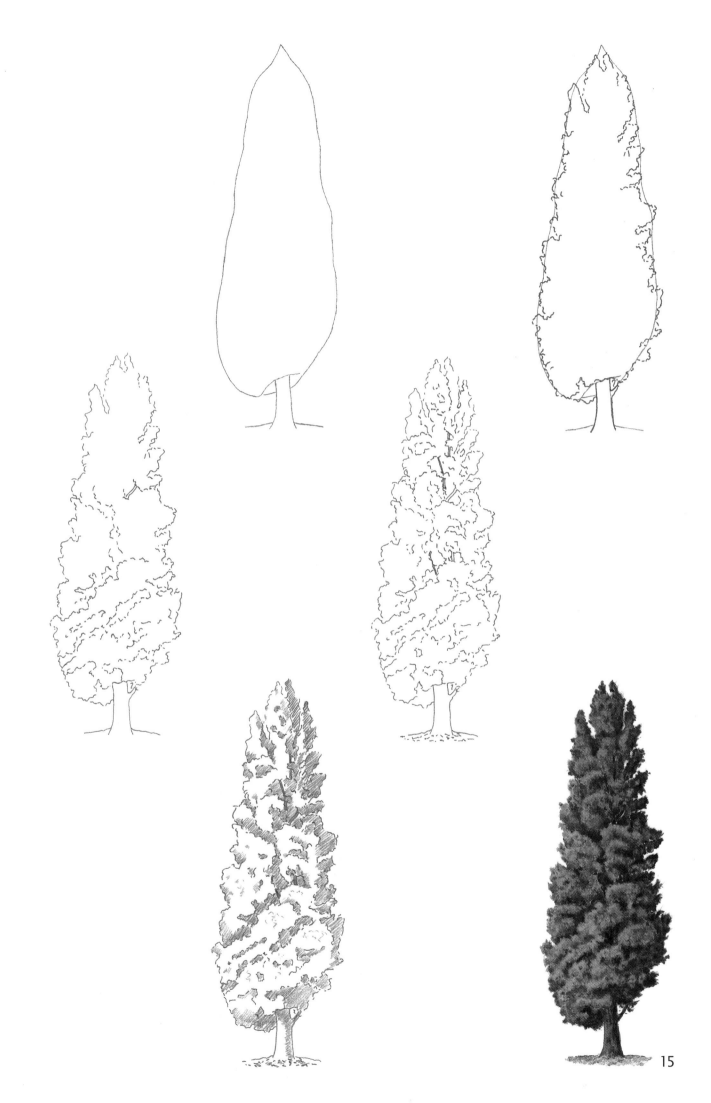

15

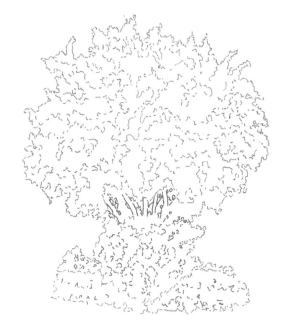
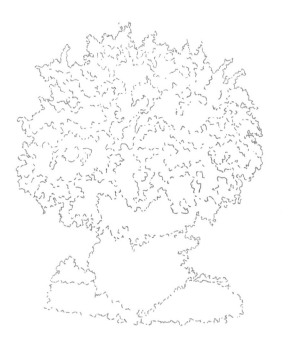
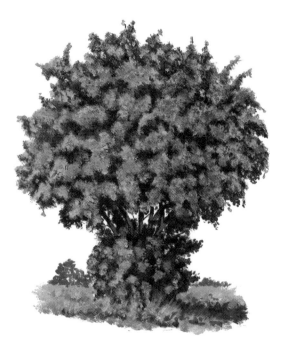
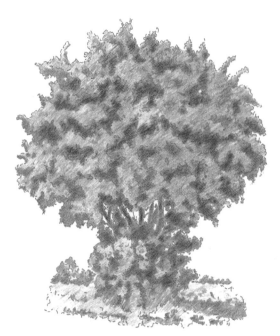

16

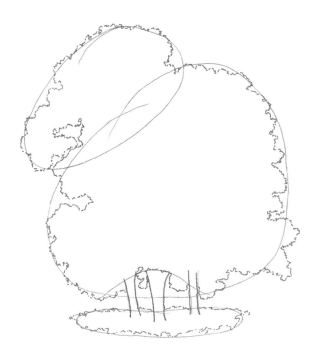

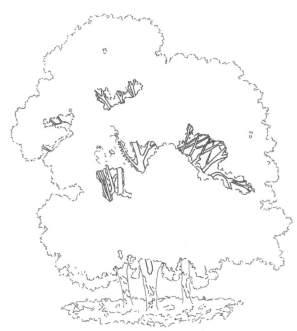

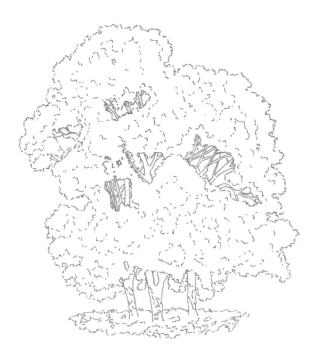

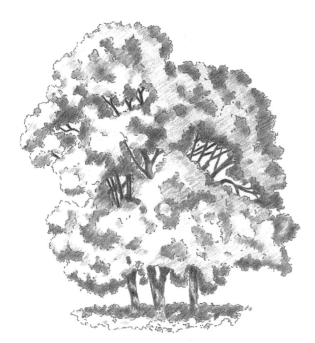

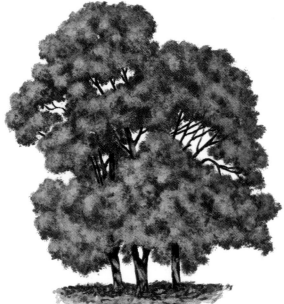

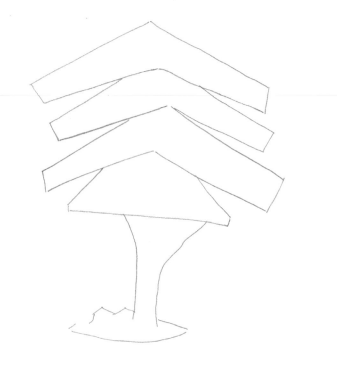
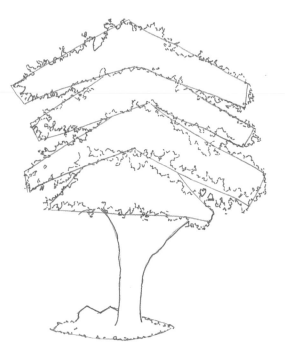
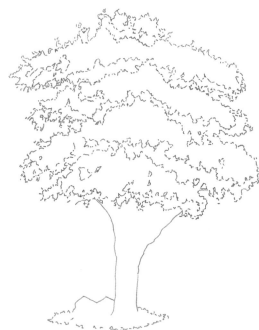
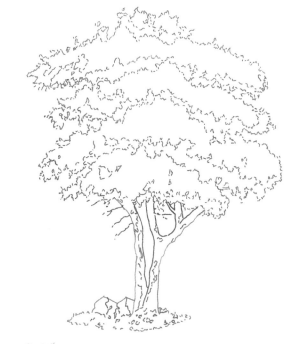
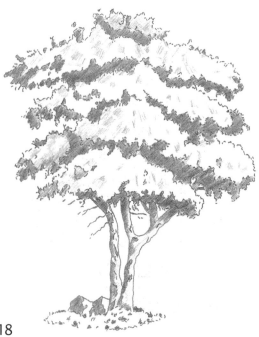
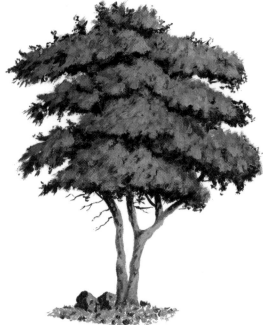

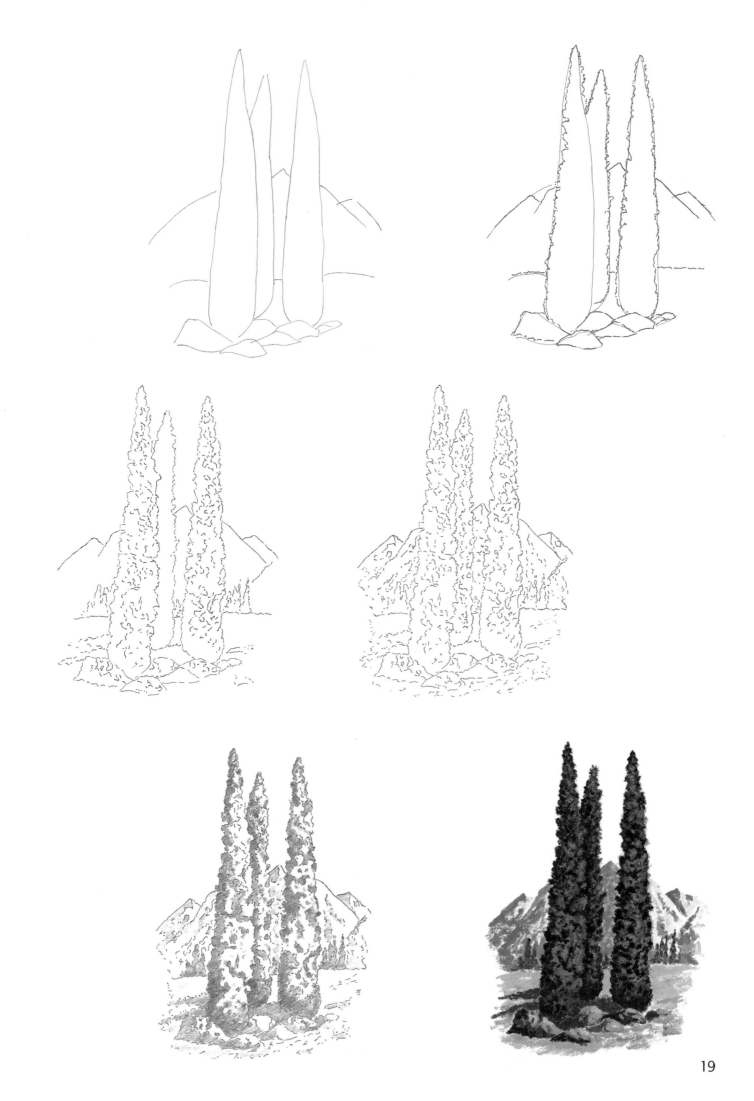

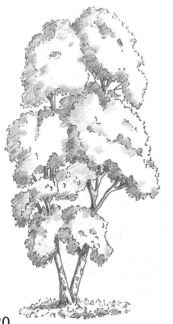

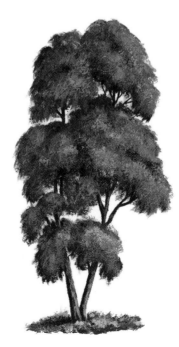

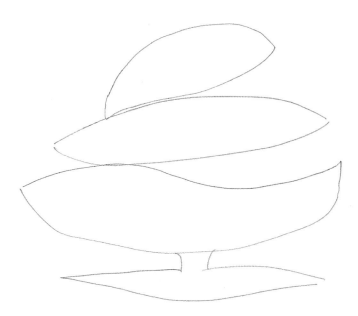

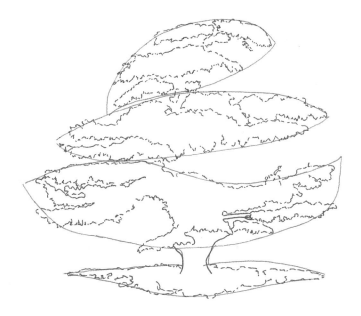

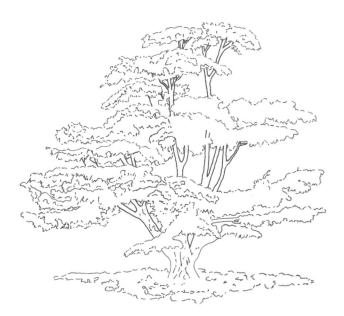

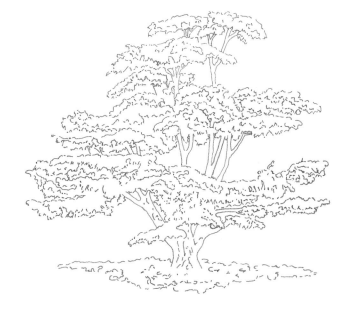

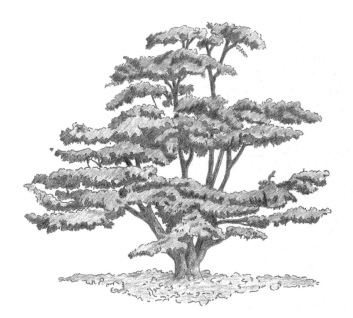

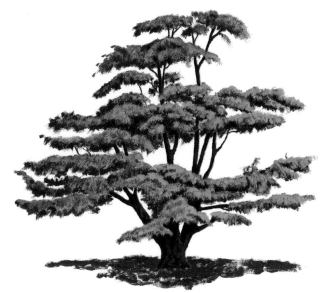

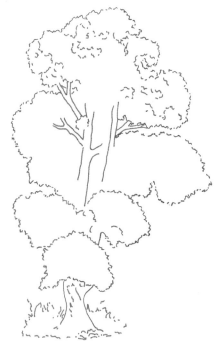

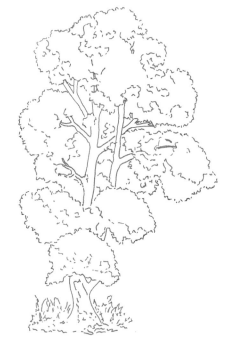

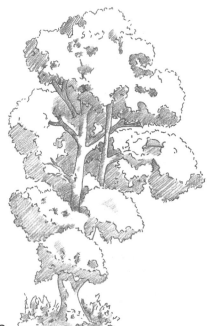

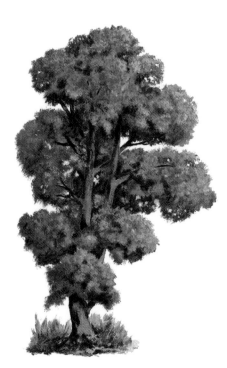

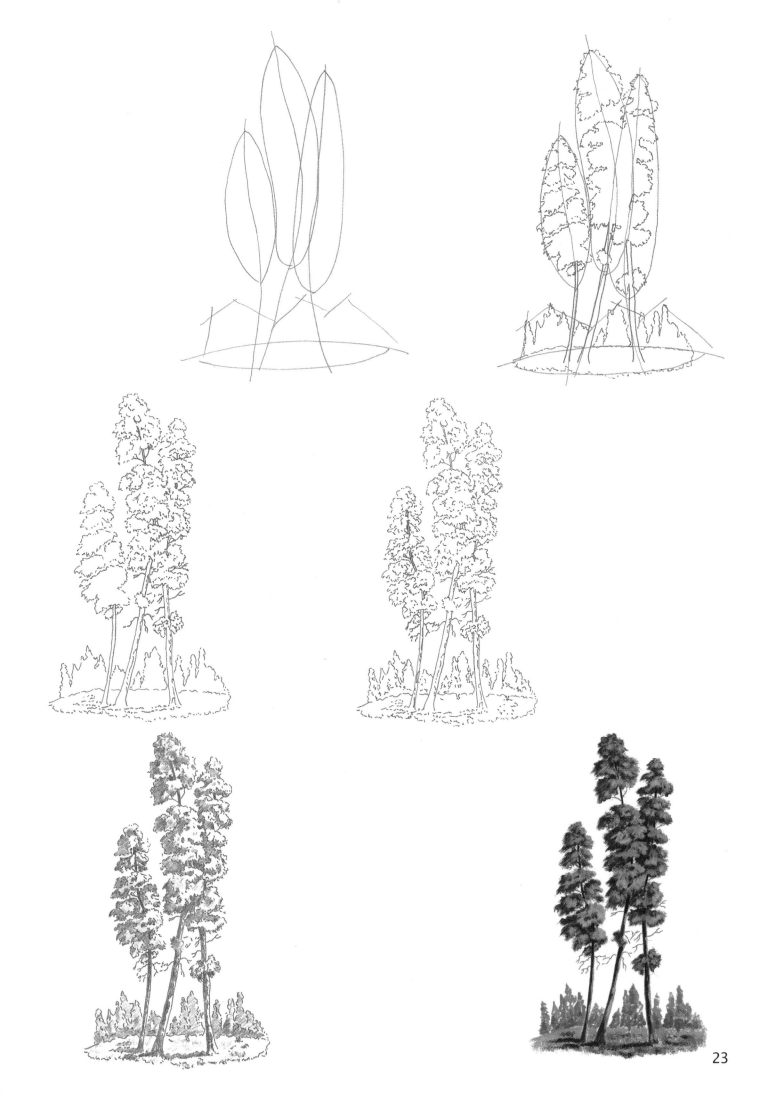

23

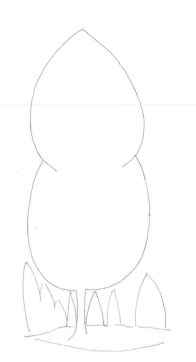

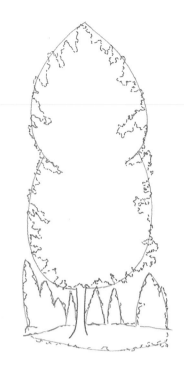

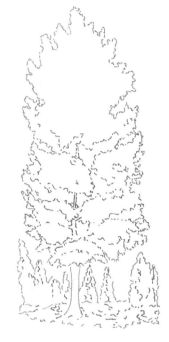

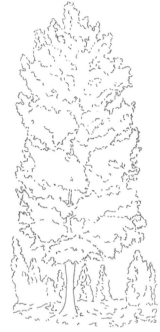

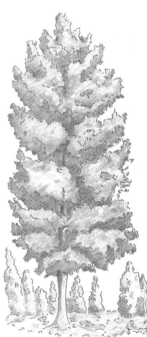

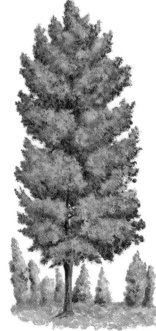

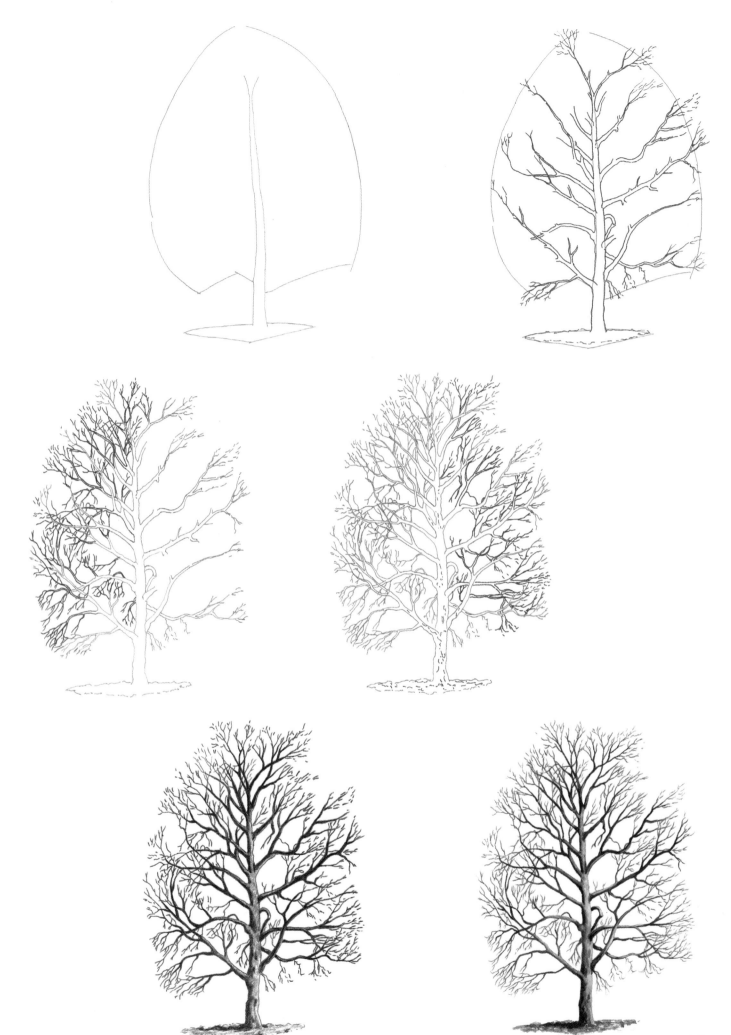

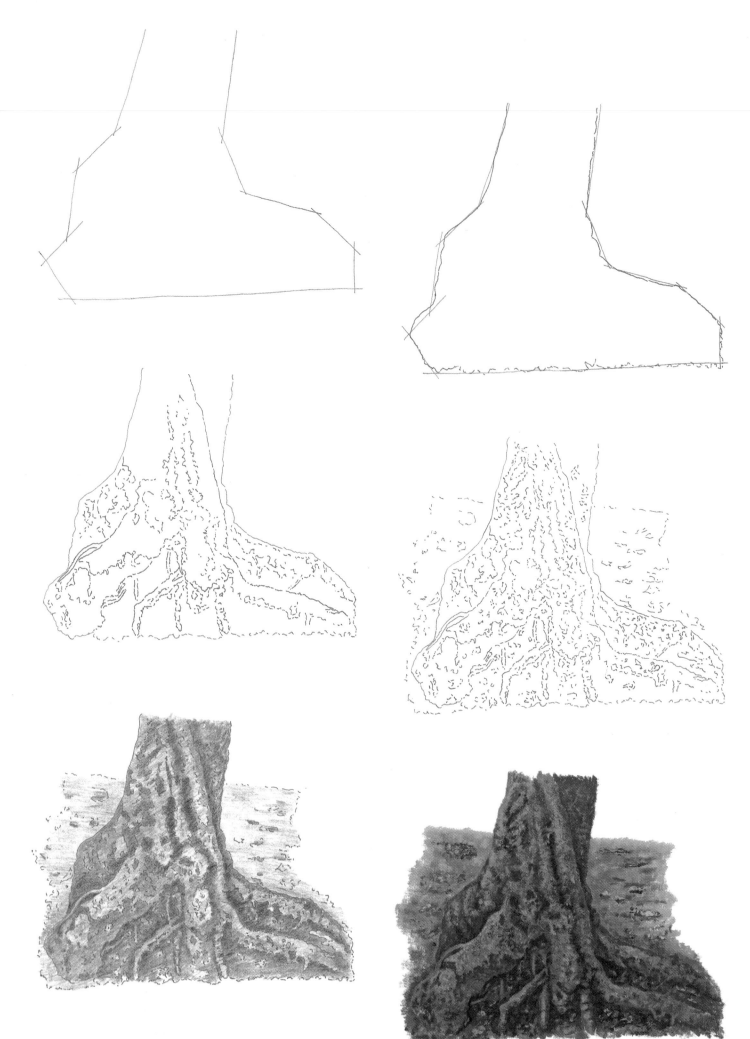

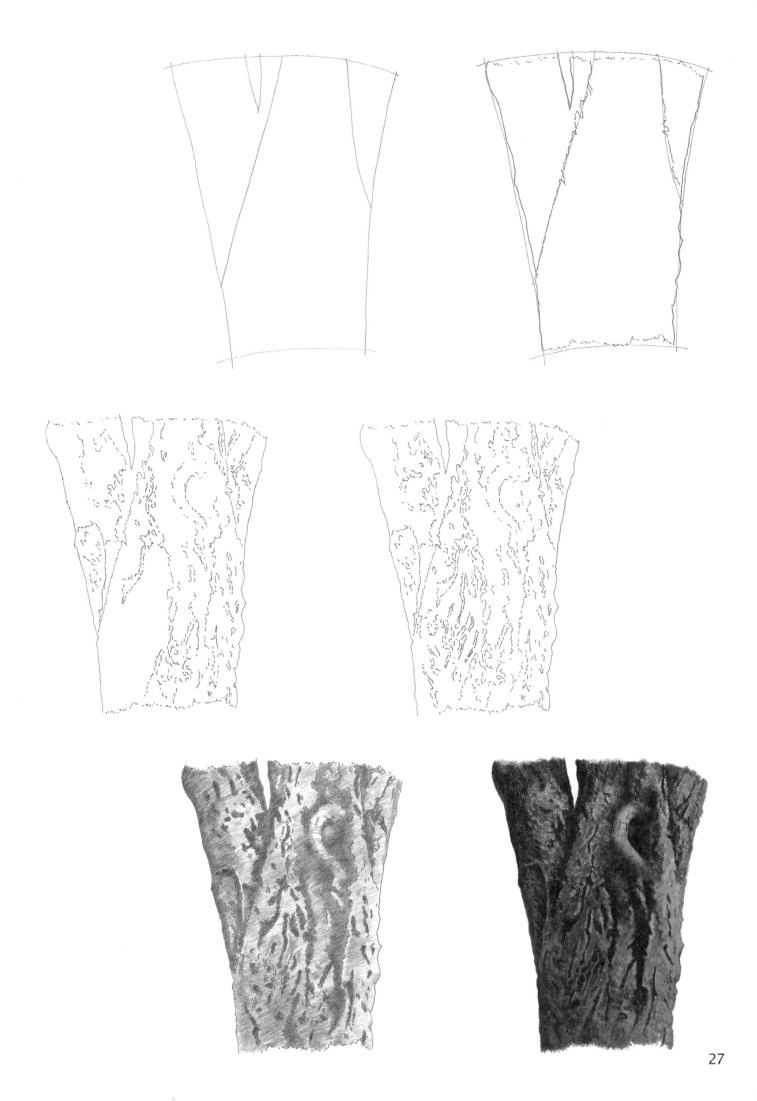

27

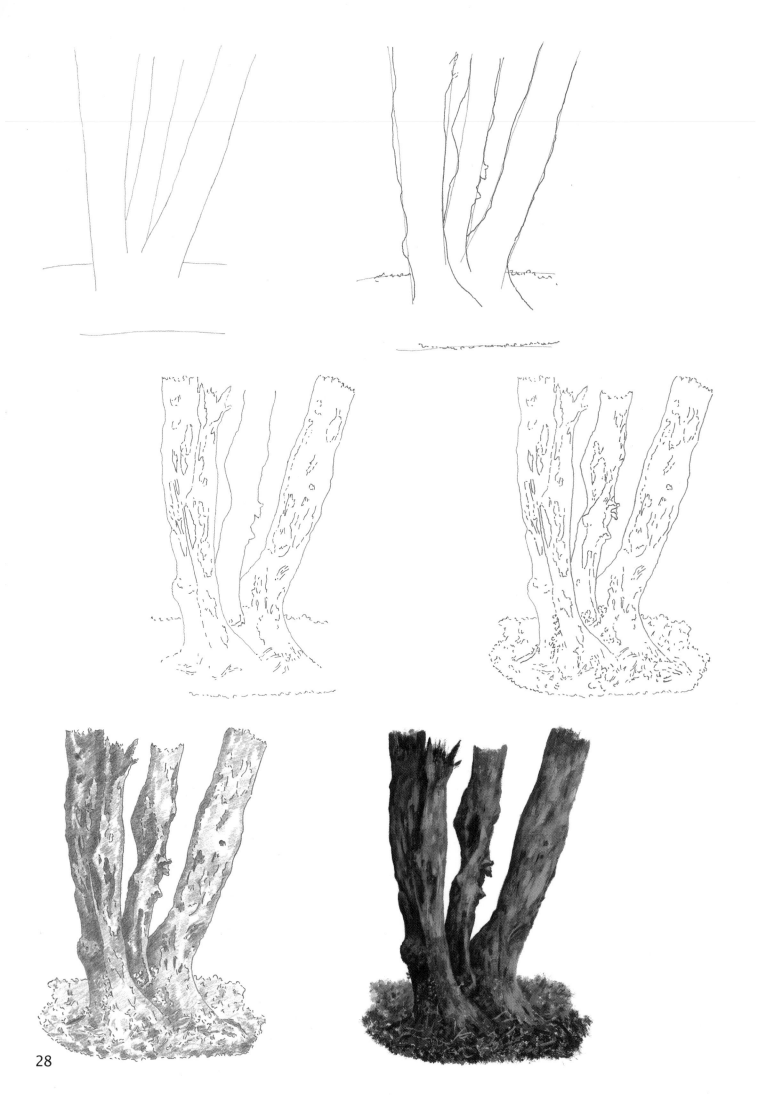

28

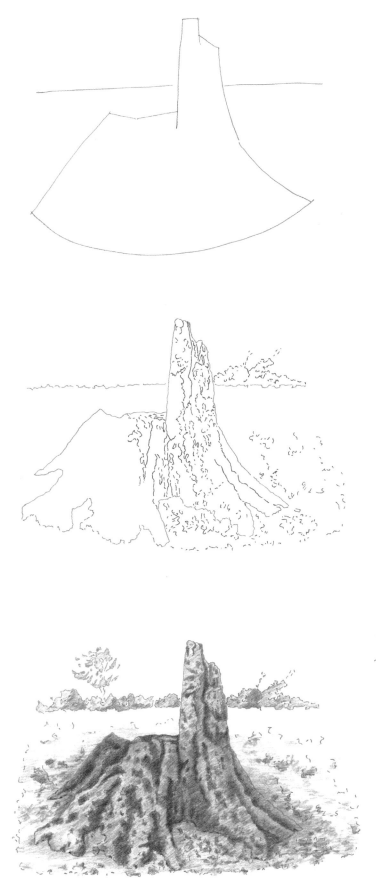

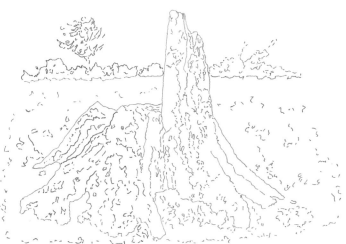

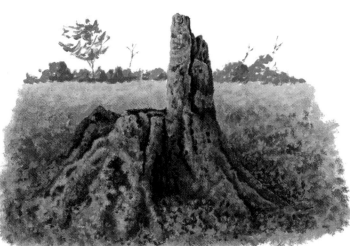

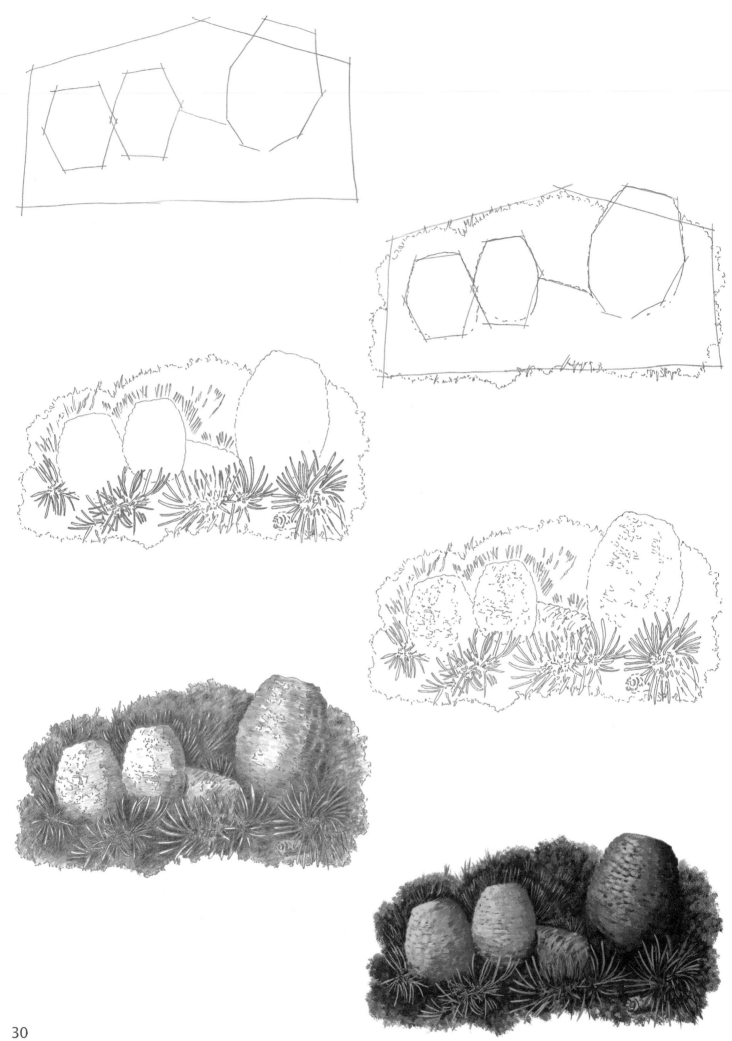

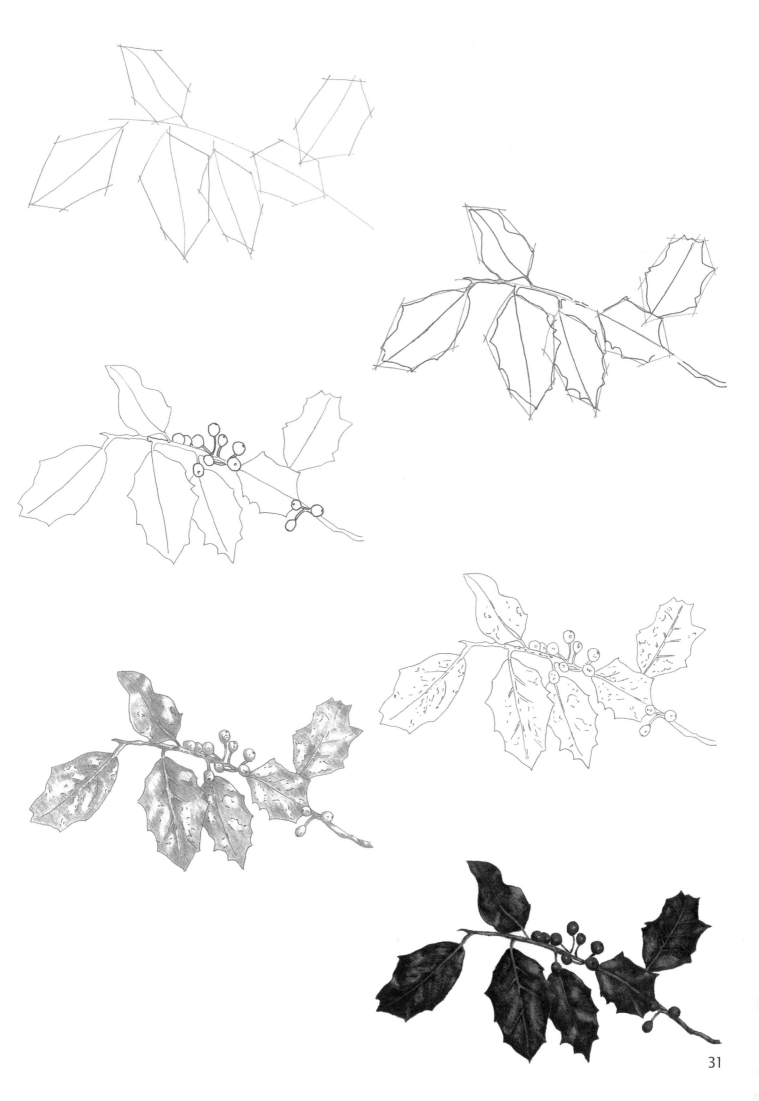

31

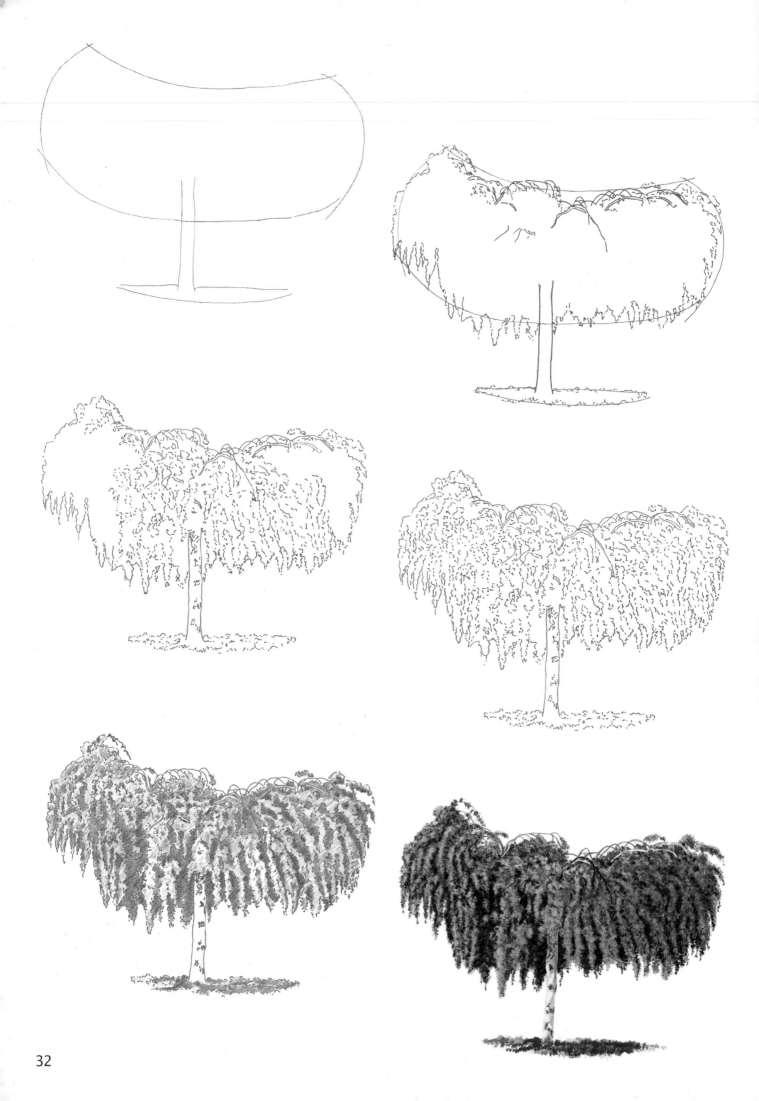